PHOTOGRAPHING THE WORLD

MARGARET
BOURKE-WHITE

PHOTOGRAPHING THE WORLD

MARGARET BOURKE-WHITE

A People in Focus Book

BY **Eleanor H. Ayer**

DILLON PRESS
New York

Maxwell Macmillan Canada
Toronto
Maxwell Macmillan International
New York Oxford Singapore Sydney

For my father, William S. Hubbard, who first opened my eyes to the beauty of black-and-white photography.

Acknowledgments

The author wishes to thank Mike White and Roger White for their assistance.

Photo Credits

Front cover: Courtesy of AP—Wide World Photos
Back cover: Courtesy of Roger White
Interior: Roger White, 6, 16, 35, 47, 48, 56, 98; Margaret Bourke-White, Life Magazine © Time Warner Inc., 27, 52, 59, 60, 72, 79, 82, 91

Library of Congress Cataloging-in-Publication Data

Ayer, Eleanor H.
 Margaret Bourke-White : photographing the world / by Eleanor H. Ayer.
 p. cm. — (People in Focus)
 Includes bibliographical references (p.).
 Summary: Traces the life and accomplishments of the noted photojournalist who served as a foreign correspondent for the magazine "Life" during World War II and the Korean War.
 ISBN 0-87518-513-4
 1. Bourke-White, Margaret, 1904-1971—Juvenile literature. 2. Photographers—United States—Biography—Juvenile literature. 3. Women photographers—United States—Biography—Juvenile literature. [1. Bourke-White, Margaret, 1904-1971. 2. Photographers.] I. Title. II. Series: People in focus book.
TR140.B6A28 1992 770'.92—dc20
[B] 91-39800

Dillon Press
Macmillan Publishing Company
866 Third Avenue
New York, NY 10022

Maxwell Macmillan Canada, Inc.
1200 Eglinton Avenue East
Suite 200
Don Mills, Ontario M3C 3N1

Macmillan Publishing Company is part of the Maxwell Communication Group of Companies.

First edition
Printed in the United States of America

10 9 8 7 6 5 4 3 2 1

Contents

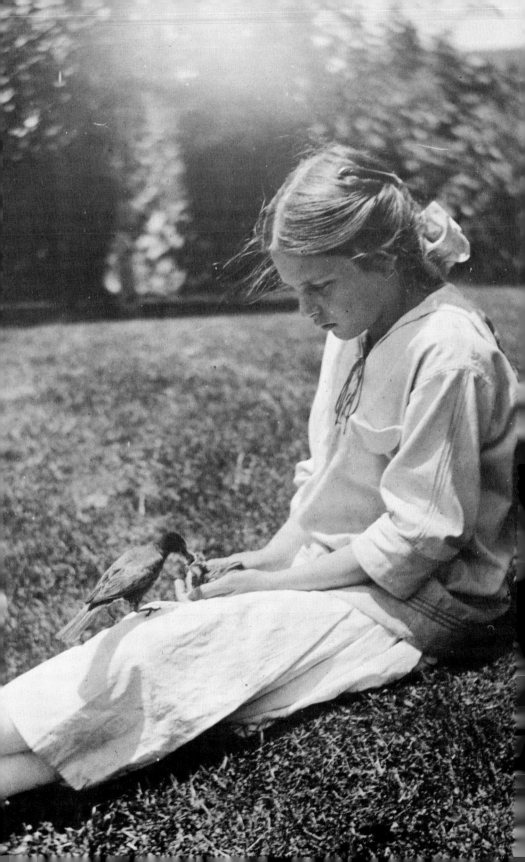

Chapter/ One

Margaret Is Invited into the World

"Nothing attracts me like a closed door. I cannot let my camera rest until I have pried it open, and I want to be first."[1]

She was. Margaret Bourke-White was first to photograph some of the most spectacular moments of the 20th century. She helped to launch two of the most successful magazines in America. Drive, daring, and determination took her to the depths of Africa's gold mines and to the death camps of Nazi Germany.

Some say she succeeded in a man's world *despite* the fact that she was a woman. Others say it was *because* she was a woman. But Margaret Bourke-White owed her success in some small way to good luck. She was lucky to have been born into the golden age of news photography.

The 1920s to 1960s was the age of the Graflex

Margaret's interest in the natural world began when she was a girl.

camera: a big, black box with a single lens mounted on the front . . . sheets of four-by-five-inch negative film . . . silver flashguns with big bulbs that exploded showers of light on their subject . . . photographers crouched behind tripods draped in black cloth, waiting for the perfect moment to shoot. . . . This was the age of the finest black-and-white news photos ever taken.

The dawn of photojournalism still lay ahead when, on June 14, 1904, Margaret was "invited into the world."[2] Joseph and Minnie White believed that children should be invited by parents who wanted and welcomed them, that they were living proof of their parents' love for each other.

Margaret's older sister, Ruth, had arrived by a previous invitation. Her brother, Roger, was invited later. Their father, Joseph, wanted his children to have a home where faith in each other would always hold the place of honor. Although they did get along well, Margaret later said that her brother and sister were not a big part of her childhood.

She was born in the Bronx, New York, at a time when only rich people owned cars. Shining steel machinery was just beginning to come into the factories of America. Joseph worked for a company that built printing presses. He was an inventor. Day and night his mind was filled with ideas. He would go into a restaurant, order a meal, spend the whole time sketching

on a napkin, and leave, never touching his dinner.

"Work, work, work," he once wrote in a letter to Minnie. "That's what we know to be our salvation." Constant attention to his work and ideas made Joseph a quiet man. "If only Father would talk more,"[3] Minnie often sighed to her children. They would ask a question and it might be hours before Joseph would answer. One time it was the next afternoon!

Margaret understood her father's quiet ways. She admired his dedication to his work. In fact, she said, her father gave her "the most valuable inheritance a child can receive." This gift was the rule by which he ran his own life: *"Never leave a job until you have done it to suit yourself and better than anyone else requires you to do it."*[4] Margaret would follow that rule on every photography assignment she undertook.

When she was four, the family moved to Bound Brook, New Jersey, so her father could be closer to his work. In this small town, with woods and streams nearby, Margaret learned to love wild creatures. Early in life she decided that biology would be her career. She pictured herself traveling to far-off parts of the world in search of rare animals for zoos or museums. Her specialty, she decided, would be herpetology: the study of reptiles and amphibians.

It was very important to the Whites that their children learn to live without fear. To teach this lesson,

Father brought home some of nature's less lovable wild things. One day he bought for Margaret's zoo a baby boa constrictor in such delicate health that it needed to be held in a blanket. She also had an old puff adder snake that liked to curl up in her mother's lap. As she watched them rocking before the fire, Margaret knew her mother was uneasy. "But how could she show her fear when [I] was unafraid?"[5]

To help Margaret get over her fears of the night, Mother invented a game. After dark they would race around the outside of the big house. Margaret would run one way; Mother would head the other. To keep the little girl from getting too scared, Minnie would run quickly around the first three corners to meet her. Night after night they played. Soon the idea of winning became more important to Margaret than her fear of the dark. Minnie then wisely slowed her pace, leaving the child alone longer in the dark until she was afraid no more.

Another important value in the White household was respect for truth. Truth must be "requisite No. 1 for a photographer," Bourke-White wrote in her autobiography, *Portrait of Myself*. When she was a little girl, she recalled, if she broke a plate her mother would say, "Margaret, was it an accident or was it carelessness?"

"If I said it was carelessness, I was punished; an accident, I was forgiven. [I was] judge of [my] own behavior."[6] Her mother believed that truth was more

important than a broken plate.

Although Joseph and Minnie White made a secure home for their children, they also made it clear that life was not meant to be lived just for fun. Time was not meant to be wasted. Margaret, Ruth, and Roger were expected to set and reach tough goals.

Sometimes, it seemed to Margaret that her mother's rules were a bit too harsh. "We were forbidden to visit [the] homes of our playmates if their families subscribed to the funny papers."[7] Likewise, she missed many of the early great movies because Minnie believed that movies were "too easy a form of entertainment for a child."[8]

Entertainment for Margaret was often a trip with her father to the factory where his printing presses were made. She loved these visits as much as other children loved the movies. The roar of the huge machines, the clang and clatter so loud that no voices could be heard, all fascinated Margaret. She agreed with her father when he said that machines were as beautiful in their way as the loveliest scene in nature. She could not know at eight years old how important this "art of the machine" would later be to her career. One day Margaret would photograph massive machines with the same perfection that her father had designed and built them.

Margaret was very close to her father. They thought alike, they had the same deep-set eyes, and they shared a love for adventure. But one part of his life Joseph did

not share with his daughter—the fact that he was Jewish. The White children were raised in a nonreligious household. Mother Minnie, who was Irish Catholic, was not fond of her in-laws. She made certain that the children saw little of their Jewish grandparents.

Many Americans in the early 20th century held strong anti-Jewish feelings. Not wanting to bring hardship on his family because of his background, Joseph did not tell his children he was Jewish. When, as a young adult, Margaret did learn her father's secret, it came as an unpleasant shock. A psychiatrist at last encouraged her to talk about her feelings, which helped ease her mind. Throughout her life, Margaret would support blacks and other minorities. But never would she mention that she herself was half Jewish.

Work was much more of a religion to Joseph White than Judaism. Joseph and Minnie were perfectionists, and they expected their children to be best at whatever they did. While Roger and Ruth tried hard to please them, only Margaret ever seemed to succeed.

She spent the first eight grades in Bound Brook in a four-room school where she was one of the smartest students. Often she would call attention to herself by walking into the classroom with a snake wrapped around her shoulders. Father had taught her that there is a fine line between showing off and drawing attention to oneself. The first was wrong; the second was okay.

For high school, Margaret went to nearby Plainfield.
Biology and English, particularly writing, were two
of her top subjects. She was never the most popular
girl; her clothes were plain and her hair not stylish. But
she was a leader and the other students knew it. She was
intelligent and they respected her. But she was rarely
part of the crowd.

It hurt to be a wallflower, especially for someone
who loved to dance as much as Margaret did. When
she won the school essay contest in her second year, she
figured that finally those dull days were over. The eyes
that watched her as she walked on stage to claim her
prize on graduation night would be waiting for her
at the dance that followed. The music began and
couples filled the floor, but the only person who asked
Margaret to dance was a girlfriend of her sister Ruth.
It was most embarrassing. "I am sure," Margaret later
wrote, "that . . . from the bottom of her generous heart,
[Ruth's friend] wished as fervently as I that we both
could be stricken invisible."9

Long after she was famous and had had many
boyfriends, it would still bother Margaret deeply that
she had never been popular in high school. In some
ways she blamed her strict upbringing. But the White
children knew from the start that they were expected to
live up to high standards.

The children had been taught to figure out answers

to problems themselves. They learned to enjoy being alone. Above all, their mother said, they must be curious, open to new ideas. "OPEN ALL THE DOORS," she would say. "Search out . . . "[10] With her camera, Margaret would later do just that.

Chapter / Two

Phrenology, Photography, and Herpetology

Being terribly curious about her future, Margaret took up handwriting analysis. Her handwriting, she decided, showed that she had good business sense, a dramatic flair, and a talent for science. These surely would be helpful qualities as she roamed the world in search of rare snakes and animals for museums and zoos.

After a brief try at palm reading, she decided to talk to an expert on futures. With a friend, she went to see a phrenologist—a person who studies the bumps on people's heads to learn about their personalities and futures. Like many fortune-tellers, the woman expressed ideas that were so general she was bound to say something right. But a few of her predictions were strangely correct. "You are always ready to go any place that is suggested to gather news and information," the

phrenologist told Margaret. And "you should always take photographs of places you have been."[1]

But at age 15, Margaret had never used a camera. Photography was one of her father's interests. With his inventor's mind, he was constantly experimenting with lenses, lighting, and darkroom chemicals. Although she had posed for him and helped him in the darkroom, Margaret claimed never to have used a camera until after her father died.

That sad day came in January of 1922, when Joseph White suffered a stroke. Later Margaret wrote, "My great love for my father and the fact that he was so much interested in photography was a strong . . . incentive [for me]."[2]

When her father died, Margaret was in her first year of college at Columbia University in New York. Joseph had never been good at managing money. He thought money an unimportant result of work and never did any job just to get paid. When he died, he left the family with very little. Fortunately for Margaret, her uncle paid for the rest of college that year.

At Columbia, she found herself as distant from her fellow students as she had been in high school. Once again she was the respected leader but not the popular friend. This bothered her deeply. By the end of her freshman year, none of her few dates had asked to kiss her. Why, she wondered, did men respect her and yet stay so far away from her? Did all the talk about her

Margaret the herpetologist

future career make men think she didn't need them? That being something she could not change, Margaret focused her tremendous energy on studying, which she thoroughly enjoyed.

Following the interest in cameras that her father had sparked in her, Margaret signed up to study with Clarence H. White, one of the finest photographers of the day. At that time a great debate was raging. Was photography a kind of art? Or was it nothing more than learning to use a piece of equipment? Clarence White belonged to the group that felt photography was an art form. From this gentle teacher, who was careful never to criticize his students unkindly, Margaret learned to compose every picture with an artist's eye. "Chance is a poor photographer,"[3] White often said. He encouraged his students to plan each scene with care and vision. Having grown up with perfectionist parents, Margaret did not find it hard to live up to White's standards.

That summer she took a job as the photography counselor at a camp in Connecticut. Although her main chore was to teach photography to the campers, she also found time to start her own postcard business. At first she photographed the cabins so each child could buy a souvenir to take home. She quickly expanded to other scenes around camp and sold her cards through the local gift shop in town. When the summer was over, Margaret had made more than 2,000 postcards!

As successful as her business was, it was not enough to pay for her second year at college. As if by some miracle, shortly before school began she had a call from two wealthy people who enjoyed helping talented students get an education. The Mungers offered to pay Margaret's way. When she told them she would like to study herpetology, they suggested the University of Michigan, where the renowned zoologist Dr. Alexander G. Ruthven was a professor. With a promise to the Mungers that she would stop selling postcards and focus all her time on her studies, Margaret headed west.

During the first half of the school year, she met with Dr. Ruthven to talk about her future. Both Margaret and the professor saw that although she was a good student, "she was not the kind of clay that could be molded into a successful herpetologist." When he asked her what she did want to become, she told him "a photographer." Dr. Ruthven agreed to help, recalled Margaret, on one condition: "that I make a 'world figure' of myself."[4]

At Michigan, Margaret finally found the popularity she had wanted for so long. She had dates with many men, one of whom even asked to kiss her! It was in a revolving door on campus that she met Everett Chapman. Chappie, as he was called, and Margaret quickly fell in love. It was all too fast for Margaret. As much as she had longed to be popular, she was also very serious about her career. Now, at 18, she must decide whether or not to get married.

Worry over marriage, her career, and her own personality brought Margaret to the edge of a nervous breakdown. In the 1920s, psychiatry, the study of mental illness, was a new area of medicine. Minnie, always ready to try new solutions to problems, suggested her daughter see a psychiatrist. Through many sessions, the doctor helped Margaret sort out her feelings and decide for herself what she would do. She decided to marry Chappie.

Scoffing at superstition, they chose Friday, June 13, as their wedding day. Chappie, an electrical engineer with a passion for welding, decided to make Margaret's wedding ring himself. The night before, he invited Margaret to his lab to show her the ring. Laying it on the table for one final adjustment, he tapped the tiny red-gold circle. The ring broke into two pieces.

In just two years, their marriage was also broken. About this painful and disappointing time, Margaret wrote in her diary, "I was always afraid of marriage because the woman so often loses her individuality."[5] Chappie, for his part, was bound by a mother who refused to let go of her little boy. Only two weeks after the wedding, Mrs. Chapman announced to Margaret, with hatred in her voice, "You got him away from me. I congratulate you. I never want to see you again."[6]

Looking back on her failed marriage, Margaret said, "People seem to take it for granted that a woman chooses between marriage and a career . . . weighing one against

the other . . . I am sure this is seldom so. . . . Had it not been for a red-gold ring that broke into two pieces, I would never have been a professional photographer."[7]

While they were married, Chappie's work had taken them to Indiana and Ohio, where Margaret continued her college studies. When at last they decided to separate, Margaret headed for New York State. There, at Cornell, the seventh university she had attended, she finally focused on her future. She still knew so little about photography that "it seemed almost impudent to think about taking pictures to sell."[8] But looking around at the beautiful waterfalls and ivy-covered walls of the campus, she decided there must be other students who would like to buy photos of these lovely scenes.

She was right. Soon she had a staff of student salespeople. During graduation week, they sold her entire collection of pictures. Margaret's specialty was buildings, and she began receiving letters from architects asking if she planned a career in photography. A New York company advised her that she could "walk into any architect's office in the country with that portfolio and get work."[9] Margaret decided to try.

But first there was some unfinished business. Returning to Cleveland, she quietly completed her divorce from Chappie. It was then that she picked up her middle name (her mother's maiden name), added the hyphen, and became Margaret Bourke-White.

Chapter / Three

Doing the Things Women Never Do

Cleveland was a steel mill town with trains and coal barges constantly coming and going. Giant smokestacks filled the sky with soot 24 hours a day. The dirt, the noise, the roaring blast furnaces attracted Margaret like a magnet. But they were strictly off-limits to a woman. Since childhood, Margaret had known her lifework would involve "doing all the things that women never do."[1]

The business world of the 1920s was a man's world. "People don't take a woman seriously," Margaret would later write. "They are afraid to trust her on the job. Or they think she is going to get married in the next ten minutes and won't finish it. Or they think that she is too temperamental to work with."[2] Margaret maintained that though it was harder for

a woman to enter a profession, there were many advantages for women in the workplace. She never complained of discrimination.

Cleveland would give Margaret her first challenge in a man's world. Trudging through the streets with her portfolio, looking for work, the young photographer passed a black preacher in a park. His arms were spread wide and his voice was raised as he preached the word of God to his intent listeners—a large flock of pigeons. What they were intent on was finding scraps of food in the park.

Recognizing a great picture, Margaret dashed to buy a bag of peanuts for the birds—but wait! She had no camera. Running to a nearby photography store, she excitedly described to the clerk this photo that simply must be taken. Without question the clerk loaned her a Graflex camera and she was off.

She sold her preacher and the pigeons photo for ten dollars. But more important, she made a friend of the clerk, Alfred Hall Bemis. He would be of unending help and advice with future photography assignments. "Perhaps," she later said, "if there had been no Mr. Bemis, others would have helped. . . . But one would need ten others to replace [him]."[3]

It was not easy for a woman to get permission to enter the steel mills. The noisy, dirty mills were thought to be no place for a lady, and the reply was always "no."

This was not the only assignment from which Margaret would be turned away. She would hear "no" many times, from the factories of Russia to the gold mines of Africa.

At last, a banker friend agreed to write a letter of introduction to the president of Otis Steel, asking permission for Miss Bourke-White and Mr. Bemis to photograph the mill. Beme, as Margaret would later call him, remembered that first night of shooting. Margaret was "dancing on the edge of the fiery crater in [her] velvet slippers, taking pictures like blazes and singing for joy."[4]

But the joy ended back in the darkroom when they saw the finished pictures. One sheet of film after another showed only large areas of black with big spots of light. The film, the cameras, the lighting, or perhaps all of them had not been right for photographing steel mills. Thankfully, the president of the mill was in Europe on business. When he returned, he would want to see her photos, but for now there was still time to try again.

Night after night, Beme borrowed different equipment from the store. Lighting seemed to be the major problem. In the 1920s flash attachments had not been invented yet. One day Beme announced that a friend was in town selling a new photography tool—magnesium flares. He would let them try a few flares in the steel mills. These flares proved to be their answer.

The new pictures were spectacular.

Beme drove with Margaret to the mills on the day she was to show her prints to the president. Sitting in Patrick, her battered green Chevrolet, he told her not to be nervous. "Child, you've come through with an armful of pictures the like of which no one has ever seen until now."[5] The president agreed. He purchased eight of the photos on the spot and made plans for a Bourke-White book called *The Story of Steel.* During 1929 several midwestern newspapers printed Margaret's photos of machines and industry. A short time later she received this telegram:

> HAVE JUST SEEN YOUR STEEL PHOTOGRAPHS.
> CAN YOU COME TO NEW YORK WITHIN A WEEK
> AT OUR EXPENSE?
>
> *–Henry R. Luce*[6]

Margaret wasn't sure. Henry R. Luce's five-year-old magazine, *Time,* ran mostly news stories. Why would she want to work for a magazine that used only a few photographs? Her victory at the steel mills had given her confidence in herself. With her camera she had pried open the doors on the grand new age of industrial photography—and she had been one of the first. Photography was her life. Still, it couldn't hurt to talk to *Time.*

Sitting in Mr. Luce's office, Margaret tried to decide what he wanted from her. "Suddenly . . . it all

swung into focus. I knew why I had been called to New York, and my heart skipped a beat. Mr. Luce and his associates were planning to launch a new magazine, a magazine of business. . . . They hoped to illustrate it with the most dramatic photographs of industry that had ever been taken."[7]

The first issue of *Fortune* came out in February 1930. The feature article was a photo essay by Margaret Bourke-White—on hogs! Hogs were a wonderful choice, Margaret said, for "most of our readers would not expect to find beauty in the Chicago stockyards."[8]

Her photo essay on the Swift meat-packing plant was perfect for the first issue of a new magazine; it was an eye-stopper. It showed pigs being butchered and cut up for packing. Bourke-White and her reporter, Parker Lloyd-Smith, even went to the piggy scrap pile to show what was done with the leftovers. There Lloyd-Smith "took one sniff, bolted for the car and put up the windows tight while I took the photographs,"[9] Margaret recalled. (She did admit that she left her camera cloth and light cords behind to be burned.) Thanks to hogs and Margaret Bourke-White, *Fortune* was off to a good start. More than 60 years later, it is still one of the most successful business magazines in America.

That winter of 1929–1930, another New York landmark was born. It began as an advertising scheme. Walter Percy Chrysler set out to erect the world's tallest

Photographing the Armour Company for Fortune,
April 11, 1934

building and put his car company's name on it. Hired
to photograph construction of the new skyscraper was
Margaret Bourke-White.

The Bourke-White studio was then still in
Cleveland. But when Margaret watched workmen
attach two giant stainless-steel gargoyles—unnatural,
fierce-looking animal figures—to the 61st floor of the
Chrysler Building, she knew where her new studio
must be. "There was no place in the world that I would
accept as a substitute."[10]

Not only did she want her studio near the gar-
goyles; she wanted to live there, too. But there was a law

in New York that said only janitors could live in office buildings. What did Margaret do? Applied for a job as a janitor, of course! On being turned down, she decided her only choice was to work both day and night. This, she discovered, was not such an unpleasant chore. "I loved the view so much that I often crawled out on the gargoyles, which projected over the street 800 feet below, to take pictures of the changing moods of the city."[11] Sharing space with the gargoyles were two pet alligators and some turtles. They lived on the terrace outside the Bourke-White studio and entertained many flabbergasted clients.

It was good to be closer to *Fortune*. Despite the Great Depression, which caused many companies to fail and businessmen to go bankrupt, America was in the shining age of industry. The ten years from 1925–1935 brought great advances in photography—excellent equipment, better lighting, new types of film and film processing. Thanks to modern printing methods, magazines were able to run high-quality photographs.

Fortune printed some of the finest. As one of its chief photographers, Margaret Bourke-White was truly in the right place at the right time. "We all find something that is just right for us. After I found the camera I never really felt a whole person again unless I was planning pictures or taking them. . . . When people ask what I do and I tell them I'm a photographer,

they never know what a thrill it is for me to say that."[12]

Always on the lookout for new subjects, Bourke-White turned her attention to Russia. While huge factories and giant machines were making everything in America—from cars to radios to canned food—the industrial age was just arriving in Russia. Machines and factories were new to that country. And the Russian people were in love with them, like children with new toys.

Bourke-White realized that no one was photographing this new age of Russian industry. When she suggested that *Fortune* send her to Russia, the editors weren't too sure. No foreign photographer had yet been allowed inside Soviet Russia, and they were afraid Margaret would not be able to accomplish much. The assignment could be a waste of time and money for the magazine.

In 1930, the editors agreed to send her to Germany to do a story. But from there, they said, she would be on her own. When her assignment in Germany was finished, Margaret packed a trunk with canned food, for a great famine had struck many parts of Russia. Her preparations made, she set off on what might well be a futile mission.

Later Bourke-White would call the country "a lesson in patience." Every time she tried to arrange for travel or permission to take photos, she would be given some new and mysterious excuse. In Russia she faced

an even tougher challenge than getting into American factories with her camera. "The day after tomorrow,"[13] Russian officials kept promising. But that day would come and go and still the factory doors remained closed to the lady with the camera.

Not about to quit, Margaret decided to bring out her photos of American machines and factories to show the Russian people. They were so delighted that she asked if they would like to see pictures of their own factories and machinery. Indeed they would, so Margaret reminded them that she needed to get into those factories soon, for her time in Russia was running out.

At last "the day after tomorrow" arrived. Armed with her cameras, Margaret entered the new world of Soviet industry. She brought back the first pictures of Russia ever to be taken by a non-Soviet citizen.

This Russian trip was the first of several. The Eastman Kodak company gave Bourke-White free film to shoot movies of Russian industry. But motion pictures were new and Margaret's movies were not very good. "I did all the wrong things," she admitted. One of her biggest errors was taking "still" shots with a movie camera, "forgetting," she said, "that the important word in motion pictures is 'motion.'"[14]

She returned in 1932 to photograph the Russian people, among them the great-aunt of Russian leader Joseph Stalin. She found the old lady near the earthen

hut in the tiny town where Stalin was said to have been born. "With her bent shoulders and [many] gray wool scarves wrapped around her head and neck, she looked like some great land turtle about to tuck itself into its shell."[15]

Helpful native guides next took her to the town where Stalin's mother was living. Where had Bourke-White come from? the lady wanted to know. She had heard of America, but she didn't know where it was. Again Bourke-White tried the movie camera.

"We went out into the garden in the fading light, and I tried to photograph her coming down a long flight of steps. There was scarcely a ray of daylight left. And as I cranked away while she did her little sequence, my movie camera leaped open and coils of Stalin's mother came out on the ground. I barely managed [a] . . . retake before sundown."[16]

Back in the States, many movie companies were interested in Bourke-White's films. But being a perfectionist, Margaret wanted to handle the editing and cutting herself. The delay cost her the chance to sell her films. By the time she finished editing, no one was interested. "I put the films back in their round tin boxes and decided to write them off as a loss."[17]

Once again the course of history and a little luck came to the rescue of Margaret Bourke-White. Relations between the United States and Russia began to improve.

Newspapers ran more stories on the country and Americans became interested in Russians. Margaret's book, *Eyes on Russia*, which contained 40 photos from her trip, became very popular. Within a short time, two Bourke-White films were playing in American movie theaters: *Eyes on Russia* and *Red Republic*. But they were the beginning and the end of Margaret's movie career. Never again did she touch a movie camera.

Chapter / Four

The Beginning of Margaret's Awareness of People

During the Depression, when millions of people were bankrupt or out of work, Margaret Bourke-White was making $35,000 to $50,000 a year. Demand for her work made it necessary for Bourke-White to increase her staff from two to eight people. One of the most valuable members of her team was Oscar Graubner, her darkroom technician, who would stay with her through much of her career.

For a time, Bourke-White specialized in photomurals: enlarged photographs that could be hung along walls in order to tell a story. Her most famous photomural was for NBC radio and was hung in Rockefeller Center in New York in 1933. She also tried her hand at color photography and experimented with the new 35mm cameras that were just coming on the market.

Increasing fame (and *Fortune*) brought Margaret contracts from many big companies to take pictures of their products for advertising. Photographing 10,000 pieces of chewing gum or dozens of fingers reaching for new brands of nail polish offered her exciting new challenges. What did it take to be a good advertising photographer? The biggest question one must answer, said Bourke-White, was whether a photo was convincing. A photograph of polished silver "must look more like silver than silver itself."[1]

To make her photos convincing, Bourke-White and her staff went to great lengths. For *Ladies' Home Journal* magazine, they accepted an assignment to photograph strawberry mousse ice cream—in color. Color photography was new and unreliable in the 1930s. Unlike the faster black-and-white film, color needed a long exposure time under bright lights. To photograph ice cream under bright lights seemed impossible, but Margaret and her crew decided to try. They would shoot the real thing, not some fake concoction made to look like ice cream. Determining, by Oscar Graubner's calculations, that they needed a full 90-second exposure, they turned on the blazing floodlights. "I held the shutter control in my hand as I counted off the lagging seconds," Margaret later wrote in her autobiography. "I could see the mousse softening. ... On the eighty-fifth second, like an Alpine avalanche,

Goodyear tire advertising photo, taken about 1933

it slid majestically downward, collapsing in rivers of pinkest foam. [But] I had pushed the trigger just quickly enough to catch the image of the mousse intact with a little blur—that hint of movement which has become so popular in recent years."[2]

Although Bourke-White was in great demand to photograph some of America's most important products, among them Buick cars and Goodyear tires, she never considered herself an advertising photographer. "The real gift of the advertising business to me was practice in precision. I never felt I was a very good advertising photographer, but the practice I got

while I tried to be a good one was invaluable."[3]

New products needed very convincing ads. In the 1930s, air travel was new and frightening to many people. Companies such as TWA and Eastern wanted ads that would convince the public to try flying. Margaret Bourke-White was the perfect photographer, for she loved air travel. "Airplanes to me were always a religion,"[4] she admitted.

Eastern hired her one summer to photograph a plane full of passengers as it flew beside her own plane over New York City. Among those Margaret invited to be the "passengers" she would photograph was her mother. At the time, Minnie was taking a course at Columbia University. As she stood up to tell the class about the great adventure she would have the next day, she fell over. Minnie White was the victim of a heart attack that would claim her life two days later.

Margaret had respected her mother greatly, but it was her father for whom she had always cared most. Those closest to her say she showed little emotion at her mother's death. She was out of town at the time and left a message with her secretary regarding funeral arrangements. The pace of her growing career left her little time to mourn for her mother.

Bourke-White spent half of each year as an advertising photographer. Although it was not her favorite kind of photography, she badly needed the money that advertising provided. It was expensive to

rent a fancy studio on the top floor of a New York skyscraper. Margaret was not a good businesswoman. Despite her large income she was often in debt. More than once she had borrowed money from her mother.

The other half of her year Bourke-White spent at *Fortune* doing news and feature assignments. "I was always glad when *Fortune*'s time rolled around again,"[5] she recalled. In 1934, *Fortune* sent her to the Midwest to cover a story that was still unknown to most Easterners. Middle America was in a great drought. Millions of acres of farmland stood parched and cracking, the topsoil blowing into billowing clouds of silt in a blackened sky.

Margaret had five days to do the story. Realizing the vastness of the area she must cover—from the Texas Panhandle to the Dakotas—she chartered a small plane. Only later did she find out that the tiny Curtiss Robin was an old model, really not fit for such an assignment. "The little Robin held up quite well. Crash it finally did, but very gently and only after sundown of my last day."[6]

Taking pictures in a dust storm was a real challenge. "The winds blow such a gale that it is all my helper can do to hold my camera to the ground. The sand whips into my lens. . . . Soon there is no photographic light."[7] Margaret was tremendously moved by the lifeless landscapes she was photographing. But it wasn't the wind or the dirt or the parched land that touched her heart the most.

"I had never seen people caught helpless like

this in total tragedy," she wrote. "They had no defense
. . . no plan. They were numbed like their own dumb
animals, and many of these animals were choking
and dying in the drifting soil. . . . I think this was the
beginning of my awareness of people . . . as subjects
for the camera."[8]

Margaret's photographs of the Dust Bowl told
Fortune readers how desperate America's midwestern
farmers were. She was interviewed on radio shows
and asked to write articles about what she had seen.
Always her focus was on the people. In a story for the
Nation, which ran in May 1935, she wrote, "This can't
go on. . . . This year there is an atmosphere of utter
hopelessness. No use digging out your chicken coops
and pigpens after the last duster because the next
one will be coming soon. No use trying to keep the
house clean. . . . No use even hoping to give your cattle
anything to chew on when their food crops have
literally blown out of the ground."[9]

The Dust Bowl was a turning point in Margaret's
life. "It was very hard, after working with the drought
and with the people who must weather it . . . ," she
wrote, "to return to the advertising world again and
glorify that rubber doughnut on which the world
rolled."[10] She was speaking of her latest assignment—
photographing tires for a rubber company ad. To
show the size and strength of its tires, the company

handcarved a wooden "tire" with diamond treads to run through piles of fake sand. The tracks that it made were big and impressive. The company then shipped to the Bourke-White studio a specially made rubber tire, fatter by far than an ordinary tire, which it hoped customers would believe had made the tracks in the photo. It was getting hard for Margaret to take "convincing" photos and at the same time keep her promise of "utter truth" in photography.

A short time later, Margaret had a dream. "Great unfriendly shapes were rushing toward me. . . . I recognized them as the Buick cars I had been photographing . . . their giant hoods raised in jagged alarming shapes as though determined to swallow me." She realized then that the time had come for her to get out of advertising photography. "If I believed in piloting one's own life, then I should go ahead and pilot mine."[11]

As if to make her decision final, the day after the dream she was contacted by an ad agency. Would she be interested in doing a series of five photos, each one to pay $1,000? Though she had never received that much money for single pictures, still it did not take Margaret long to make up her mind. "No thank you," she said. She was not interested. Her decision, she explained, "was based on a great need to understand my fellow Americans better."[12] From now on, she would photograph people.

Chapter/ Five

You Have Seen
Their Faces

It seemed like a miracle to Margaret. For months she had been dreaming about a project that was very important to her. She wanted to photograph her fellow Americans. She wanted to show the hearts and souls of real working people. Her biggest quandary was how to present her pictures. What medium should she use— magazine, newspaper, photo essay? She enjoyed her assignments for *Fortune*. But a magazine article could show only a small slice of her idea. She did a great deal of newspaper photography. But a newspaper would show an even smaller slice. Only a book, Margaret decided, would allow her the space for an in-depth study. But a book would need an author.

That's when the miracle happened. Late in 1935 Margaret heard of an author in search of a photographer.

This author was famous for a book that was now being performed as a play. *Tobacco Road* was a story of share-croppers, poor farmers who "rented" land from an owner and paid the rent by giving up part of their crops. In the book, Erskine Caldwell showed what a life of poverty the southern sharecroppers led. *Tobacco Road* was so real that readers said it was exaggerated. They wouldn't believe that people in America actually lived this way. Caldwell wanted to prove to his readers that such poverty really existed. To do this he planned to write a book, which he wanted to illustrate with photographs.

Caldwell was impressed with the quality of Bourke-White's pictures, but he didn't like working with women. Neither did he like the types of pictures Bourke-White took—advertising photos. Nevertheless he decided to try the book with her. To relieve Caldwell's doubts, Margaret wrote him a note:

"I am happier about the book I am . . . to do with you than anything I have had a chance to work on for the last two years. I have felt . . . for some time that I was turning my camera too often to advertising subjects and too little in the direction of something that might have some social significance."[1]

Both Caldwell and Bourke-White were extremely busy with other projects. They decided to take six months to complete them, then meet in Georgia to begin work on the book. Margaret had a contract with Acme News to

shoot newspaper photographs 48 days a year. She had advertising and aerial photography projects to complete. When these were done, she headed for South America to do an educational piece on coffee growing.

Bourke-White returned to talk of a plan that excited her almost as much as the book. Henry Luce and his associates at *Time* and *Fortune* had a new idea: a magazine that would tell the news in pictures. Here was a chance to combine the immediacy of news photography with the larger format of a magazine. Margaret was on fire with enthusiasm.

"This was a year unlike any year I have ever lived through," she wrote. Being free from advertising photography "cleared the way so I could be receptive to the best of everything that came: the wonderful opportunity to work with Erskine Caldwell on the book and now this splendid advent of a new magazine. . . . My cup was running over."[2]

And her clock was running out of time. The six months until she was to meet Caldwell were nearly up. She would call him, she decided, and tell him she needed an extra week. Caldwell was already in Georgia when Margaret reached him. His reaction was not what she expected. "The frozen wordlessness at the end of the line conveyed to me [that] we might never begin [the project] at all. I could hardly believe it."[3]

Realizing that the book was in danger, Margaret

hurriedly finished her other projects and was on a plane to Georgia in four days. In the coffee shop of her hotel, she met the strangely silent man with whom she hoped to work. They drank their coffee in silence, Margaret waiting for the argument to begin. It never did. At last Caldwell turned to her and said, "That was a big argument, wasn't it? . . . When do you want to leave?"[4]

"Now," she replied. And so they did.

Margaret was used to quiet men who spent long periods in silence. Her father had been such a man. As they began their journey in Caldwell's car along the back roads of the Deep South, Margaret studied the new countryside and quietly watched her partner. With them in the backseat was Sally, Caldwell's literary secretary. Things seemed to be off to a good start.

But as the trio was beginning day five on the road, Caldwell came to Margaret's hotel room. He wanted to talk. What he said took her by complete surprise. The project was going nowhere, he felt. He saw himself as little more than a tour guide. It was time to quit.

The next 24 hours were filled with emotion. Completely confused and extremely upset, Margaret broke into tears. And then, she recalled, "something very unexpected happened. [Erskine] fell in love with me. From then onward, everything worked out beautifully."[5]

But perhaps things were not quite as smooth as Margaret wanted to believe. For one thing, Caldwell

was already married. He wrote to his wife, Helen, "The trouble is Bourke-White is in the habit of getting her own way—and so am I—what happens when we fall out is all that can be imagined."[6]

Sally decided to quit. At the hotel desk they found a note. Sally explained that she was tired of sitting in the backseat. She could work with "one temperamental writer, or one temperamental photographer," but not "two ... in the same automobile in the summertime in Arkansas."[7]

Caldwell and Bourke-White were now on their own. Almost. Their only passengers were the praying mantises wedged between them in glass jars on the front seat. Margaret planned to photograph the insects on the day they emerged from their cocoon case. The big day came as they were traveling along a back road. Hurriedly Margaret positioned the egg cases on a nearby rail fence. "I began to photograph the pouring river of midget creatures. ... I saw we were surrounded by a solemn ring of little children who ... now began delightedly singing out, 'Look at the little devil horses!'"[8] The children were fascinated, and Margaret was delighted at the new name they had given the praying mantises.

For the next few months, Caldwell and Bourke-White drove the back roads of the Deep South. They visited sharecroppers in the fields, women and children crowded into tiny, dirty shacks, prisoners on a chain

gang, their spoons wedged into the leg irons that held their ankles together. Bourke-White took hundreds of photos showing the poverty in the region.

What seemed impossible to photograph, however, was a white church service. While the black churches were open to everyone, the door of the all-white Holiness Church, Caldwell and Bourke-White found, was locked from the inside. Spotting an open window, they leaped through it, cameras flashing. Apparently the churchgoers were too busy singing, shouting praises, and rolling on the floor to notice that they were being photographed. But when the noise died down, the intruders knew it was time to leave. "We sailed out through the windows the way we had come in, and in a matter of minutes we were out of town."[9]

People trusted Erskine Caldwell because he had a southern accent, but they looked upon Margaret as a foreigner. They also trusted "Skinny" (the only nickname you can get out of "Erskine") because of his quiet manner. He would listen patiently while a person told as much as he wanted about himself. Observing him, Margaret began to learn a whole new way of working. She used to act like a movie director, sometimes telling people just which way to stand or move. But more often now she would sit quietly in a corner while he talked with people, waiting an hour or more to get just the right expression before taking a picture.

The poverty of the Deep South was so far removed from the rush and glitter of New York that it seemed like another world. Little did Margaret expect to be thrown back into the advertising world by walking into a sharecropper's shack. But staring out at her from the dark, dirty walls were pictures of ladies in lovely gowns, children playing with expensive toys, and the newest models of cars with their huge hoods and fat tires. These people papered their walls with magazine ads, Caldwell told her, to keep out the heat of summer and the cold of winter. Margaret had the uncomfortable feeling that if she looked around enough, she would find advertisements she had done herself.

After two months of living with sharecroppers, it was time to return to New York. The project had jolted Margaret "into the realization that a man is more than a figure to put into the background of a photograph."[10] She was learning to understand people and to be concerned about the conditions that made up their lives.

Back in New York they worked on getting the book into print. There were thousands of photos from which to choose. Each photo they used would need a caption. On captions, Skinny and "Kit" worked together. (Caldwell called Margaret "Kit," for he said she often wore the expression of a kitten who has just finished a bowl of cream.) They returned to the Deep South one more time, in the spring of 1937, to take care of some last-

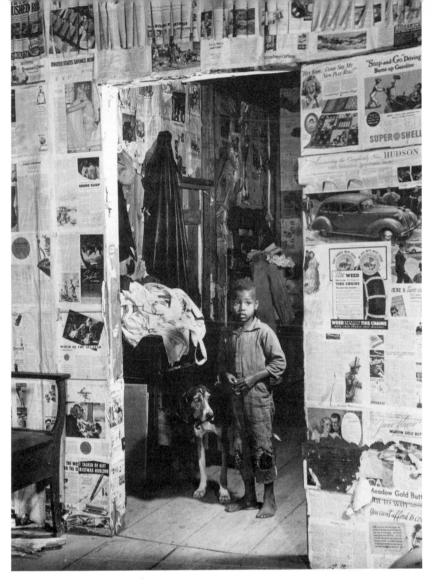

A sharecropper's shack in Louisiana, from You Have Seen Their Faces. *"I had the uneasy feeling that if I explored long enough I would find advertisements I had done myself."*

minute details before the book was published that fall.

You Have Seen Their Faces became what one writer called "a publishing milestone, a force for social good, and a great popular success."[11] It was the first book to

Ozark, Alabama, from You Have Seen Their Faces

use more photos than text to tell a story. It showed just how bad social conditions in America really were. And it sold far beyond everyone's expectations.

Not all comments were good. Some reviewers claimed Bourke-White had staged the photographs and hired actors to be in the pictures. Others thought photographers should find pleasant subjects rather than take pictures of the bad things in life. But many critics agreed with the review in the *New York World Telegram:* "The pictures have the quality of the very finest portraits. They depict man and the intention of his soul."[12] Margaret Bourke-White had helped to pioneer another field of photography.

Chapter / Six

The Birth of Life

The peak of Margaret Bourke-White's career still lay ahead. On September 4, 1936, she signed a contract with yet-unborn *Life* magazine. *Life* would be the first picture magazine in America and Bourke-White would be its star photographer.

The founder of *Life*, Henry Luce, thought that people needed a way to get their news faster than they could in long newspaper or magazine articles. Because there was no television yet, the picture magazine became the perfect answer. Luce's vision was to have the magazine "see life; to see the world; to eyewitness great events." He wanted *Life*'s readers to "take pleasure in seeing; to see and be amazed; to see and be instructed."[1]

With these ideas in her mind and only two weeks until deadline, Bourke-White took off on her first assignment.

She was to photograph construction of the Fort
Peck Dam on the Columbia River in Montana, the
world's largest earth-filled dam. It was a project of the
New Deal, President Roosevelt's plan to put unemployed
people back to work during the Great Depression. A
boomtown called New Deal, Montana, had grown up
around the dam site.

In New Deal, Margaret found much more than a
new dam. She photographed the faces of construction
workers, both on the job and after hours as they
danced and partied. She took pictures of their children
and their homes—simple shanties that showed what
a hurriedly built town New Deal was. *Life*'s editors
didn't plan to put the Fort Peck story in the first
issue of the magazine. But Bourke-White's pictures
were so good that just one day before deadline, Henry
Luce himself chose the Fort Peck Dam for *Life*'s
first cover photo. Margaret's picture story of New Deal
would be the magazine's lead article *and* the first
photo essay in America.

With the photo essay, Margaret Bourke-White
pioneered another form of journalism. She was often
chosen to do photo essays, which she greatly enjoyed.
"When the editors called me in on a story which they
referred to as the 'Bourke-White' type of story," she
later wrote, "this made me very proud."[2]

She could even turn late-breaking news stories into

photo essays. Margaret was on the last plane into Louisville, Kentucky, before the airfield was closed during one of America's three worst floods. She shot part of her photo essay from a first-aid rescue rowboat. That night she slept on a desk in the city's flooded newspaper office, and the next day she took one of the most famous photos of her career. A group of black people were standing in line waiting for flood relief. Behind them was a huge billboard showing a comfortable white American family in a new car. The billboard read, "There's no way like the American way."

But not all the Bourke-White photos were high quality. The day of President Roosevelt's second inauguration was gray, overcast, and drizzly. Margaret was perched in the Washington press stands with dozens of other photographers, hoping for a good shot of FDR. Just as his car passed her, the president turned his head and smiled. Overjoyed at her good luck, she raced to the darkroom to supervise the developing of her film. To her horror she discovered she had underexposed the negative so badly that the outline of the president' face was barely visible, "just enough to show how wonderful the picture would have been,"[3] Margaret mourned.

Bourke-White photographed both America's presidents and its scoundrels. Just across the river from her New York office, Jersey City was ruled by a mayor

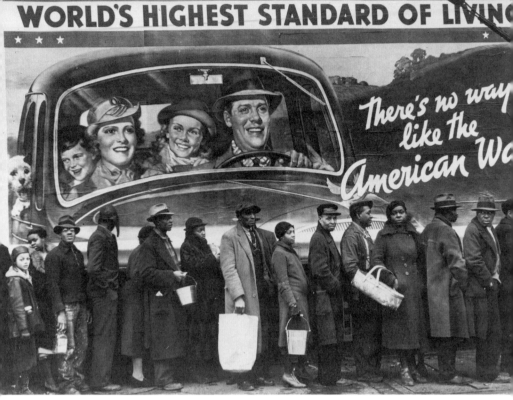

Bourke-White's famous Louisville Flood photo

who proclaimed, "I am the law."[4] He made sure reporters saw only his good side. But Margaret and her staff knew about his bad side and they wanted to tell the story. Bourke-White's plan was to become friends with the mayor. Once he trusted her, she hoped to sneak her camera into forbidden places. One of those was a huge tenement building where young children were made to work long hours in very dangerous conditions. When the day came to try her daring plan, Margaret was too afraid to shoot a full roll of film at one time. "As soon as I got three or four shots on a roll, I dispatched one of my helpers over to New York with it. I knew . . . I would be arrested before long, so I worked

feverishly. . . . [Sometimes] I did not pause even to reload cameras, but handed them with the exposed films stilled inside to my helper, who stuffed them out of sight somehow and made his escape."[5] Thanks to the Bourke-White staff, Jersey City's corrupt mayor was exposed nationwide on the pages of *Life* magazine.

Margaret's staff members were always very special to her. Among the most important was her darkroom technician, Oscar Graubner, who had worked with her from the time she moved to New York. Oscar developed her negatives and made her prints with far more talent and skill than Margaret herself had in the darkroom. Many famous photographers said Oscar Graubner was the best darkroom technician they knew. He played a major part in making Margaret Bourke-White a famous photographer.

Peggy Sargent, Margaret's longtime secretary, began working for her in 1935. When Bourke-White moved to *Life*, the magazine promised her an office with Peggy as her secretary and a darkroom headed by Oscar Graubner. Later Peggy became a film editor whose job was to sort through hundreds of negatives with a careful eye, as Margaret had taught her, looking for the few very finest pictures.

Bourke-White was not the only great photographer on the *Life* staff. Alfred Eisenstaedt would become nearly as famous as Margaret, and one of her close

friends. Carl Mydans, another great who came to *Life* from newspaper work, said that Margaret taught him "to worship the quality of a photographic print. . . . She was a perfectionist. Little that she ever did really satisfied her."[6]

Mydans and Eisenstaedt were experts with small cameras, the 35mm models that were just coming into use. Margaret was queen of the big cameras, which helped to bring her fame. For a time she was also the only woman on the photographic staff of *Life*. Some people thought that publisher Henry Luce played favorites with Margaret. It is true that she got a number of the prize assignments. It is true that she had her own darkroom and a staff, while the other photographers had to develop their own film, working together in one darkroom. The men were understandably jealous of Margaret. But they couldn't deny that she brought to *Life* a quality of photography that most of them could never equal.

Bourke-White would go anywhere and take nearly any risk for *Life*. In the summer of 1937, a new Canadian official, Lord Tweedsmuir, was visiting the far northern part of Canada and *Life* wanted a story. On exactly one day's notice, Margaret was on a small plane with His Lordship, two other passengers, and Art (the pilot), photographing the beautiful icy world of the Arctic far below. Art had removed one of the plane's

doors, leaving a giant hole through which Margaret could shoot pictures. He did insist that she tie a rope around her waist in case she should lean out a bit too far, but fortunately it wasn't needed. The excitement and panic came in another way. "I was very busy photographing," Margaret recalled. "Then I realized there was no more color . . . ice and sea and sky lost their boundaries and all turned gray together. We had run into one of those sudden treacherous [Arctic] fogs . . . there was nothing for Art to do but look for a place to bring the plane down as quickly as possible."[7]

It wasn't quite that simple. Finding a good landing place in the dense fog was almost impossible. The tiny island they finally found was surrounded by the frigid Arctic Ocean, cold enough to make a strong swimmer completely helpless in just four minutes. Art guessed they were 300 miles from human life. The fog could last six hours, he said, or six weeks. While her companions pondered their fate, Margaret took pictures. Although the plane's radio was not strong enough to send messages, it could receive them, and soon weather reports started coming in. One of the broadcasts ended with a message for "Honeychile" from Erskine: "When are you coming home?"[8]

After nearly two days, the fog lifted briefly, just long enough for them to fly off the island and make it to a small Eskimo village. From one Arctic fur-trading post to another, the "Honeychile" messages

MIND YOUR HEA[D]

With husband Erskine Caldwell near a railroad boxcar, 1941.

followed Margaret. One read, "COME HOME AND MARRY ME." *Signed Skinny.*[9]

At last, her Arctic assignment completed, Bourke-White was ready to go home. But was she ready for marriage? Margaret was not at all sure. For one thing, Erskine Caldwell already had a wife and children. For another thing, he could go into horribly quiet, grouchy moods, which Margaret called "freeze-ups." When Erskine was himself, he was a gentle, sensitive, highly talented man. But when he slipped into a freeze-up, it was terrible to be around him. Margaret wasn't sure she could handle those moods.

But perhaps most important in considering

marriage was her career. "It was not that I was against marriage. . . . [But] my first loyalty was to *Life*. There was no secret about it. My professional work came first. . . . Dashing off at a moment's notice around the globe is wonderful if you are doing the dashing yourself. But if you are the one who stays behind, it must be hard to bear."[10]

Yet as practical as Margaret tried to be, she had to admit that she and Erskine were in love. They each knew that there would be major hurdles to overcome, but they were ready to try. On February 27, 1939, in the ghost town of Silver City, Nevada, with their cabdriver from Reno as a witness, Margaret Bourke-White and Erskine Caldwell were married.

Chapter / Seven

Bourke-White Goes to War

Bourke-White's new goal was "to photograph the next war . . . if there's got to be one."[1] In 1938 *Life* sent her to Spain to cover that country's civil war. Erskine went with her to Europe. They were working on a new book, *North of the Danube*, and needed to spend some time in Czechoslovakia. On May 28, shortly after they arrived, German leader Adolf Hitler announced that he would "wipe Czechoslovakia off the map."[2] World War II was about to erupt, and once again Bourke-White was in the right place at the right time.

 October of 1939—one month after Hitler invaded Poland and the war had begun—found Margaret in England. She roamed the streets with her camera while London waited to be bombed. In December she left for Romania, a country whose oil supply Hitler very much wanted to

Training the Hitler Youth in Czechoslovakia, 1938.
From North of the Danube.

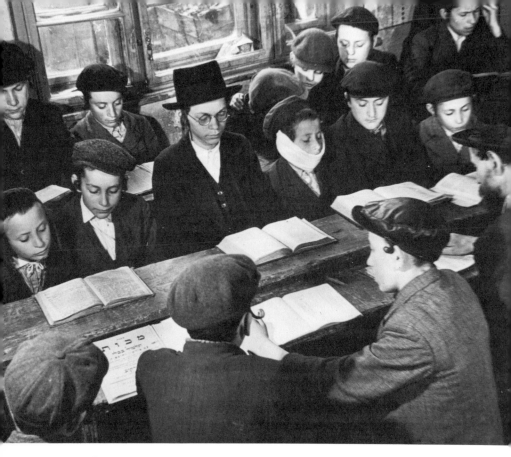

A class of Jewish students in Czechoslovakia studies the Talmud, 1938. From North of the Danube.

take over. Next she was off to Turkey and, by March, to Syria, to photograph the desert troops moving by camel train.

From Syria, Margaret cabled *Life* with some surprising news. She was quitting. She wanted to join the staff of a new publication. *PM* would be the first truly photographic newspaper in history. Margaret saw it as another exciting "first" for her in photojournalism.

But that was not her only reason for leaving. As exciting as her assignments for *Life* had been, there were things about the magazine that bothered her. "It

was heart-breaking," she wrote editor Wilson Hicks, "to see that a series that we had . . . [worked] night after night [for], usually all night, could count for so little that only one picture should be used."[3] Credits were also a problem. Margaret wanted her name to run beneath her pictures. But it was *Life's* policy not to give credit to individual photographers. *PM* seemed more willing to work on her terms.

The first issue of the newspaper was published June 18, 1940. By October, Margaret could see that *PM* was not going to be as successful as its founders had hoped. It was a great disappointment for everyone on the staff. Would *Life* take her back, she wondered, after their rather stormy parting. The answer was "yes." Within a month she had her first assignment.

It was 1941 and all of Europe was in the heat of war. Wilson Hicks had a feeling that Germany was about to invade Russia and he wanted a photographer on the scene. Bourke-White was ready. On her past trips to Russia, she had learned about the people and the country. She knew how to get permission to take photographs. Erskine was eager to go because his books were very popular with Russian readers. But the war made travel through Europe very difficult. They would have to go by way of China—carrying 600 pounds of luggage and camera equipment.

On June 22, Hicks's prediction came true; German troops marched into Russia. Margaret and Erskine

headed straight for Moscow, but it was now illegal to take pictures in Russia. Anyone caught with a camera could be killed. For three weeks Margaret made phone calls, wrote letters, talked with government leaders, and—when all else failed—threw herself down on the floor and cried. By July 15 she had what she wanted: permission to photograph the war.

There was only one problem. During bombing raids, Russian officials made everyone go into bomb shelters. They searched all hotels and public buildings to be sure the people had left. Margaret could find only one place to set up her cameras without being bothered—the roof of the American embassy. That first night on the roof was, she said, "one of the outstanding nights of my life. . . . It was as though the German pilots and the Russian antiaircraft gunners had been handed enormous brushes . . . and were executing . . . designs with the sky as their canvas."[4]

Here was a photographer's true test. Except when the bright bombs and tracer bullets lit up the night, it was too dark to focus a camera. To get enough light in the picture, Margaret had to mount her camera on a tripod and set the shutter for a long exposure. If the camera moved while the shutter was open, the picture would be blurred. The constant explosion of bombs made it nearly impossible to keep the camera from moving. Yet, in true Bourke-White style, with her own

life at risk, she managed to get great news pictures that were high-quality photographs as well.

Toward the end of one long night on the roof, a strange feeling came over Margaret that danger was extremely near. Instantly she grabbed her camera, slid back through the window, and dived into a far corner of the room. Seconds later a bomb exploded just outside the embassy. The blast blew in every window and sent heavy objects flying through the air. But her camera was safe and so was Margaret. Immediately she headed for the basement of the building.

When the siren at last blew an all-clear signal, meaning the raids were over for the night, Margaret emerged. Everywhere huge piles of glass littered the embassy, but it was still too dark to take pictures. Not wanting to leave these great news scenes unrecorded, she wrote a note and left it on one of the biggest piles: "Don't sweep up glass until I come back with camera."[5] When daylight dawned, Margaret returned, took the pictures, which she developed in the bathtub of her hotel room, and shipped them straight to New York. *Life's* lead story that week featured the first photos of the bombing of Moscow.

Bourke-White had gotten around a list of impossible "no's" about photographing the war. Now she had one more goal. She wanted to photograph the Russian leader, Stalin. The answer was, as always, "no." With her

usual persistence, Margaret tried all routes to her goal until she found one that worked. An important U.S. official she knew was finally able to get a "yes" for her from Stalin's staff.

When the big evening came, Margaret pondered what to wear. "Knowing that Russians like red, I put on red shoes and tied a red bow in my hair."[6] But even her red shoes failed to get a smile out of the tough, hardened Soviet leader. His face was like stone. Stalin was, she would later say, the most difficult person she ever photographed.

Margaret tried talking about his mother, whom she had photographed on her first trip to Russia. He said nothing. She tried to get him to sit down and relax. No. Finally, in desperation, she got down on her knees to photograph him from an unusual angle. As she did, flashbulbs came tumbling out of her pockets and spilled everywhere. Watching Margaret and her Russian interpreter crawling around on the floor chasing flashbulbs was apparently too much for the stoic Stalin. He suddenly began to laugh. Margaret grabbed a camera and managed to get a couple of good shots before the smiling face again turned to stone.

By September, Bourke-White was ready to go home. She had to be back soon to begin a lecture tour of the United States. Although she had hoped to photograph at the battlefront before she left, it seemed impossible to get permission. She had tried everything. Just when she had given up all hope and she and

Erskine were making plans to leave, a message came. They should be ready to leave the next morning—for the fighting front near Smolensk.

It was here that Margaret got her first taste of the real horrors of war. When a bomb exploded just outside her hotel, she ran out with her camera. Four members of a family lay dead, holding each other tightly. "Days later," Margaret wrote, "when I developed the negatives, I was surprised to find that I could not bring myself to look at the films. I had to have someone else handle and sort them for me."[7]

Just a week later she and Erskine were on a ship heading across the Arctic Ocean toward home. Less than 24 hours after they landed, Margaret was off to begin her lecture tour. But this hectic schedule was beginning to cause real problems in their marriage. Erskine wanted her home. He wanted them to have a baby. Margaret, too, would have liked a child. But she realized she could not be a good mother and a great photojournalist at the same time. She also realized that Erskine's icy moods were happening more and more often, and she was not sure she could live with them much longer.

Although she knew that her marriage was in trouble and that perhaps she should spend time at home with Erskine, Margaret could not stay away from the war. Early in 1942, she asked *Life* to send her back to Europe. At first Erskine's letters to her were gentle

and pleading. He missed her; he wanted her to come home. But war made the mail unreliable and often he didn't get replies for weeks. Finally on November 9, he sent Margaret a telegram:

HAVE REACHED MOST DIFFICULT DECISION OF LIFETIME. DECIDED THAT PARTNERSHIP MUST DISSOLVE IMMEDIATELY SINCE PRESENT AND FUTURE CONTAIN NO PROMISE.[8]

More cables would follow, but they were unable to patch the cracks in a crumbling marriage. Margaret wrote her lawyer that she probably "should have felt desperate and devastated." Instead, she confessed, "my one feeling was relief." She admitted in her letter, "I am delighted to drop all such problems for the more productive one of photography. In a world like this I simply cannot bear being away from things that happen."[9] Bourke-White had acknowledged what was most important in her life.

They did not have a stormy divorce. Neither Erskine nor Margaret ever spoke harshly about the other. Their marriage was simply over. "I believe by this time," Margaret later wrote, "both of us began to realize we were leading two separate lives that no longer fitted together. We had had five good, productive years . . . with some real happiness. I was relieved when it was all over and glad we parted with a mutual affection and respect which still endures."[10]

Chapter / Eight

Working with a "Veil" Over Her Mind

In the 1940s women did *not* wear pants. But Margaret Bourke-White was a war correspondent—the first female military photographer of World War II. Being a war correspondent meant that Margaret must dress in an officer's uniform. But what style? All the war correspondents before her had been men. Hurriedly the Army War College had to design a new officer's uniform—with a skirt!

It was not the last time Margaret would have problems working in a man's profession. As a war correspondent, Margaret had to send her pictures first to Washington to be used or inspected by the government. After that, *Life* could use them. The military also said where she could go on assignments. Margaret wanted very much to go on a bombing

mission. To tell the war story right, she felt, she must be with the pilot and the bomb crew. She must photograph the action from the air.

But the military said "no." It was just too dangerous for a woman. Besides, women were bad luck in a man's workplace. All of Margaret's begging and pleading did no good. So she turned her energy to a new assignment.

Late in 1942, Bourke-White learned that British and American troops planned to attack the Germans in Africa. After much talk, the military finally agreed to let her go to Africa—but not in a plane. That was too dangerous. Little did they know how much closer Bourke-White would come to death on a ship.

With more than 6,000 troops, she sailed in mid-December—straight into a storm in the Mediterranean. The force of the waves was so strong it threw people against the ship, breaking their arms, legs, and even skulls. That was a bad start, but the worst lay ahead.

Early in the morning of December 22, 1942, the ship was torpedoed by a German submarine. In her haste to take pictures, Margaret nearly missed getting into her lifeboat when the order came to abandon ship. As she hurried to find her boat, she noticed her mouth had become very dry. For the first time in her adult life, Margaret Bourke-White was feeling real fear. But as she looked around her, the courage she saw in her fellow passengers helped to calm her and began

to drive her fear away.

There was no time for pictures now. All hands were needed to survive. As their lifeboat slid slowly down the side of the sinking ship, Margaret mourned for the great pictures she was missing. "I suppose for all photographers, their greatest pictures are their untaken ones."[1] Hours later, in the first light of morning, Margaret finally was able to pull from her bag the one camera she had rescued and begin taking pictures of her lifeboat mates. That afternoon she got pictures of them waving to a British plane, and by evening she was recording their rescue.

This night on the boat, Margaret later said, was a "dividing point" in her life, "almost a religious experience. . . . For me it was an inspiring discovery that so many people . . . have a hidden well of courage, unknown sometimes even to themselves." Sharing this near-death experience with the others on the boat "had a profound effect on my understanding and feeling toward other human beings."[2]

Margaret's usual good luck followed her to Algiers, where the lifeboat victims landed. There she ran into the officer she wanted most to see. General Jimmy Doolittle was one of the finest pilots of World War II. "Maggie," he asked her immediately, "do you still want to go on a bombing mission?"[3] There was no question. She started preparing at once. Exactly one month from

the day she had been torpedoed, Margaret Bourke-White was flying in the lead plane of a bomber group. Their mission was to destroy the most important German airfield in North Africa. The pilot of her plane was Major Paul Tibbetts. Three years later, Tibbetts would pilot the plane that dropped the first atomic bomb over Hiroshima, Japan.

Margaret was excited. She was scared. But practical problems gave her little time to worry. B-17 bombers were not pressurized, so the crew—Bourke-White included—needed oxygen to breathe above 15,000 feet. Staying attached to her oxygen supply while trying to move around was a real problem. These rumbling warplanes were not heated either. To protect her fingers from the -40°F (-10°C) cold, she wore electric mittens. Keeping her camera shutters from freezing was an even greater problem.

Bourke-White had taken many aerial photographs and she knew how different objects could look from a plane. But she had never before photographed a bombing run. Suddenly everything looked different. "The fiery flashes darted higher. What could it be, I wondered. I'd better take a picture of it, just in case. And suddenly it dawned on me. These are our bombs bursting on the airfield. This is our target which we came to demolish!"[4] Many times throughout the raid she would shoot first and figure out later what she had photographed.

Margaret returned to the United States to find a photo of herself in the pages of *Life*. The magazine had run her pictures beneath a big headline that read: "LIFE'S BOURKE-WHITE GOES BOMBING."[5] Among the shots of the bombing mission was a picture of Margaret on the ground in the heat of the African desert. There she stood in her high-altitude flying suit: fleece-lined leather overalls and jacket, bulky boots, a padded helmet complete with goggles . . . and her electric mittens.

Both *Life* magazine and the military agreed: The bombing mission was a success. Having beaten back the Germans, Allied forces could now use North Africa as a place to launch their attacks into Italy. The troops were ready. So was Bourke-White. She had a special reason for wanting to go, and the Army had a special reason for wanting her. "While the heroes in the air had been deservedly glamorized," Bourke-White wrote in her autobiography, "not much attention had been given to the man on the ground and to his importance to the war effort."[6] Bourke-White would show Americans just how important those ground troops were.

In the Cassino Valley of Italy, Margaret was in the middle of some of the most intense fighting of the war. She learned to live under the constant threat of death. At a field hospital where wounded were being brought by the dozens, she set up her camera. Through the long

night she photographed doctors and nurses operating by flashlight. She took pictures of gun crews and hospital workers who dashed in from their posts to donate pints of blood for the desperate victims.

When they brought in Clarence, a young soldier from Texas, Margaret turned her cameras toward his cot and the nurse who took loving care of him. She even got a shot of Nurse Barnes as she dived under the cot to avoid a shell blast. Despite all efforts, Clarence did not live. "I took a last picture of those feet still in their muddy boots and with the boy's own rifle [serving] as a splint for the crushed leg. I knew I was getting dramatic pictures. If these men had to go through so much suffering, I was glad, at least, I was there to record it."[7]

Back in New York, her assignment completed, Bourke-White was called to the *Life* office by editor Wilson Hicks. At first she wondered what she had done wrong. Then they told her that a package of film had been lost. All the pictures of Clarence and the other wounded soldiers, the brave doctors and nurses under fire had been in that package. Worse yet, the pictures hadn't been lost in the wilds of the war zone. They had made it back to Washington only to disappear inside a government office building, never to be seen again. Twenty years later Margaret would write, "The wound remains unhealed."[8]

With Allied troops in North Africa

That was not the only wound she would suffer. Early in 1945 Bourke-White was back in Italy, this time in the snowy mountains north of Bologna. Here the troops camouflaged themselves by painting their faces, their clothes, and their rifles white. Even the mules that hauled supplies were covered with white sheets and pillowcases. They made wonderful subjects for a camera! At the bottom of a nearly frozen waterfall she photographed soldiers gathering trickles of water in their helmets to take a frigid bath.

Bourke-White made 300 exciting pictures and turned them in at Rome to be flown to the United States This time they never made it to Washington. Although rewards were offered in all the Italian newspapers, the film was never found.

Margaret managed to pull herself together and returned to retake the pictures. But it was hard. "You can no longer see your subjects with a fresh eye . . . everything is changed." Later she wrote, "I know very well that when you choose to record a war, you must be willing to accept the hazards of war. I think what hurt me the most was that both the losses were due not to war but to just plain . . . carelessness."[9]

By the spring of 1945, World War II in Europe was nearly over. In March, Margaret flew to Germany, where General Patton was hoping to move American troops across the Rhine River. By April 11 they had

reached Buchenwald, one of the German concentration camps. Here Jews and other "enemies" of the Nazi government were beaten, tortured, starved, and worked to death. When General Patton saw what the Nazis had done to these people, he went into a rage. Go into town, he told his men, and bring back 1,000 German citizens. He wanted the German people to see what their Nazi leaders had done.

Bourke-White was ready with her cameras when the people were marched past the remains of these dead and dying prisoners. "This was the first time I heard the words I was to hear repeated thousands of times [by the German people]: 'We didn't know. We didn't know.' But they did know."[10] Margaret herself was in a rage that people living so close to the concentration camp would claim they had not known what was happening there.

The camp at Buchenwald, Bourke-White said, "was more than the mind could grasp." She photographed piles of naked corpses, human skeletons left in the furnaces where their bodies had been burned, living skeletons who would die the next day, lamp shades made of human skin. "Using the camera," she said, "was almost a relief. It [put] a slight barrier between myself and the horror in front of me."[11]

Bourke-White went on to photograph other concentration camps, reaching one even before the

American army. The Nazis had just left and the bodies of their victims were still burning. "People often ask me," Margaret later wrote, "how it is possible to photograph such [horror]. I have to work with a veil over my mind."[12] Sometimes that veil was drawn so tightly that she hardly knew what she had photographed until she looked at her own pictures. Seeing them was like seeing the horrors for the first time.

Why did she do it? Why did she put herself in such horrifying situations to take pictures of such terrible events? "Difficult as these things may be to report or to photograph," Bourke-White said, "it is something we war correspondents must do. We are in a privileged and sometimes unhappy position. We see a great deal of the world. Our obligation is to pass it on to others."[13] She did that. And she did it better than any other female photographer had ever done it before.

Chapter / Nine

The Photographer Must Know

The war was over, but the horror was not. Prejudice against people of different races and religions was as strong as ever. Out of prejudice grew hate. Out of hate grew violence. Violence left behind the horror that Margaret Bourke-White would photograph.

Violence was just what Mahatma Gandhi did *not* want. Gandhi, India's great leader, was a nonviolent man. He spent his life in a search for truth, which he believed could be known only through tolerance and concern for his fellow man. Gandhi overcame fear in himself and taught others to master fear. His people called him the Mahatma, or Great Soul.

In 1946 he led his country in a move to break away from the British Empire, which ruled India. To do this peacefully, Gandhi felt, Indians had to become less

dependent on the British. Buying fewer products from
England was one way to break this dependence. If his
people could learn to spin, they could make their own
cloth instead of buying it from England. The spinning
wheel became the symbol of hope for Gandhi's people.

 Life sent Bourke-White to photograph India's
historic break from the British. There she found a
challenge she had faced many times before—getting
permission to photograph. Gandhi's secretary had
only one question: "Do you know how to spin?" Well,
no, she didn't, Margaret had to admit.

 "How can you possibly understand the symbolism
of Gandhi at his spinning wheel?"[1] The secretary
insisted that before Margaret could photograph the
Mahatma, she must learn to spin.

 Despite her deadlines, Margaret found herself
taking spinning lessons. Later she realized that the
lessons had taught her much more than simply how to
spin. "If you want to photograph a man spinning, give
some thought to *why* he spins," she wrote.
"Understanding, for a photographer, is as important as
the equipment he uses."[2]

 Having learned the basics of spinning, she was
ready to photograph the master. Gandhi was living, she
was told, with the "untouchables," the poorest and
sickest of India's masses of people. Filth was everywhere.
Inside a dark, dirty hut, Gandhi sat on the floor, his

Gandhi, the master spinner

spinning wheel in front of him. He said nothing, for this was his day of silence; Margaret must not speak to him. And she was permitted to use no more than three flashbulbs. The secretary had at first said no flash at all, but Margaret had begged and pleaded.

As Gandhi started to spin, Margaret shot the first of her photos. But to her horror, she realized that in the heavy heat and dampness of the Indian air, her flash was not working right. Don't panic, she told herself. Put the camera on a tripod and try a time exposure without the flash. But as she tried to pull out the legs to adjust the tripod, she found that they, too, were

victims of the Indian weather. They wouldn't move.

Try another bulb, her inner voice said. This time the flash worked perfectly—but Margaret did not. She had forgotten to pull out the slide in her camera, which allowed the film to be exposed. She was now down to one bulb. Gandhi had begun reading some newspaper clippings, but thankfully the spinning wheel was still at his side. Margaret fired the last bulb. Everything worked. The result was one of the most famous and symbolic pictures of Mahatma Gandhi ever taken.

This was not the only time that Bourke-White would photograph the Mahatma. In fact so often was she around him with her camera that Gandhi jokingly called her "the torturer." She was everywhere photographing India's struggle for freedom.

By August of 1946 she was in Calcutta, the largest city in India and one of the largest in the world. For years the Muslims and the Hindus, India's two main religious groups, had worked together toward freedom from the British. The two groups had never tolerated each other's beliefs, but British rule had prevented religious wars. Now, just when freedom seemed possible, the Muslims wanted to break away from the Hindus and form their own country. The leader of India's Muslims, Mohammed Ali Jinnah, had made a startling speech. "We shall have India divided," he vowed, "or we shall have India destroyed."[3]

Jinnah's speech caused a bloody riot between Hindus and Muslims in Calcutta. "The streets were literally strewn with dead bodies," Margaret reported. There were "an officially estimated six thousand, but I myself saw many more." Through the lens of Bourke-White's camera, the scene was almost as bad as Buchenwald, the concentration camp she had photographed in Germany. "I did my job of recording the horror and brought the pictures out for *Life*, but the task was hard to bear,"[4] she wrote years later.

After photographing Calcutta, Bourke-White went home. She was ready to begin a new book, *Halfway to Freedom*, the story of India's independence. But soon she realized that her understanding of India was not great enough to write a book. She needed to go back and learn more.

On August 15, 1947, India became independent of British rule. At the same time, Jinnah also got his way. The Muslim country of Pakistan was born out of India. But thousands of Indians had paid with their lives. Soon, Jinnah would pay the same price. His mind and body collapsed when he saw what violence and suffering he had brought upon his people. Bourke-White took the last photographs of this man who had become so tortured by his own actions. Later, in a speech about her work in India, she said, "The photographer must *know*. It is his sacred duty to look

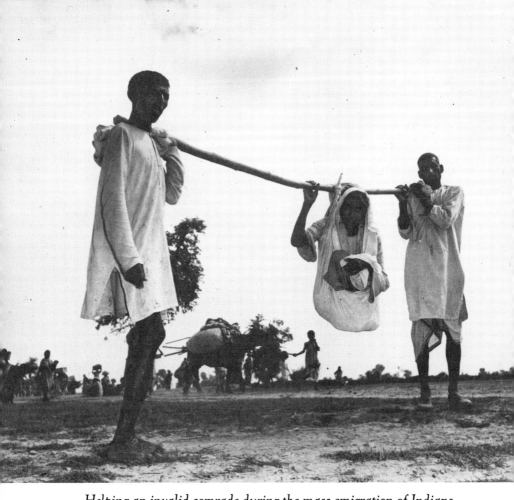

Helping an invalid comrade during the mass emigration of Indians.

on two sides of a question and find the truth."[5]

Muslims in India were fleeing to Pakistan; Hindus in Pakistan were fleeing to India. Millions of people clogged the roads, Bourke-White among them. With the refugees she tramped first through huge clouds of dust and then through mile after mile of mud caused by the worst flooding in 40 years. Fighting and death were everywhere along the route.

Tremendously upset by the religious riots, Gandhi declared a fast. He would eat or drink nothing until the violence in India ended. For five days this frail little man of 78 kept his fast. His followers heard his prayers and stopped their fighting. On the sixth day, assured that the violence was over, Gandhi broke his fast. "It was a moving experience to be there," said Margaret, "and see the people laughing and crying for joy. Gandhi lay smiling on his mattress on the floor, clutching some peace telegrams in his long, bony hands. I jumped up to a high desk and got my camera into action."[6]

Very much moved by the strength of this old man, Margaret arranged to interview Gandhi on the day before she was to go home. She admired his spirit and the way his people loved him. But much of what she had seen in India bothered her greatly. In the south she had watched children working in leather factories where lime, a chemical that burns the skin, had to be ground into the leather. The children's job was to jump into lime pits and "dance" on the leather with their feet. The bodies of these children were soon eaten away by the lime. How did Gandhi intend to help these children, she wanted to know? Was he still against bringing machinery into his country when machines could help so much to improve the Indians' way of life? Yes, Gandhi said, he was still against machines.

This was very hard for Margaret to comprehend. "While frequently I did not agree with Gandhi's point of view," she wrote, "talking with him helped me understand it. . . . He cared a great deal about reshaping the human heart, and calling out the best in every man."[7]

Bourke-White left the interview wishing Gandhi "goodbye and good luck." Just a few hours later this great spiritual leader was shot and killed—by one of his own Hindus who did not agree with his position of religious tolerance. Hearing the news, Margaret hurried back to the house where Gandhi's body lay on a straw mattress. Beside him was his spinning wheel. Around him were many of India's top leaders, a number of whom Bourke-White had come to know. She was allowed to join them—but please, no cameras.

What should she do? Here she was at one of history's biggest moments, faced with one of a photojournalist's biggest decisions. Should she respect the wishes of the Indian leaders and leave her camera behind? No, she decided, she could not. She would smuggle a camera into the quiet room. Amid the prayers and chants for the dead, Margaret pulled out her camera and fired a shot. Immediately someone grabbed it, tore out the film, and pushed her outside. Quickly Margaret put in another film and tried to get back inside. But this time officials were firm—*No.*

Realizing she must find another vantage point, Margaret joined the funeral procession, at the end of which was a great fire that would consume Gandhi's body. Along the five-mile route stood hundreds of thousands of people. "I never before had photographed or even imagined such an ocean of human beings,"[8] wrote Margaret. To photograph the burning funeral pyre, Bourke-White scrambled onto a truck. Although the drivers tried several times to push her off, she stayed. With her pictures she sent home a thought about the crowds of Gandhi's mourners: "A tiny flame was kindling in each of those million hearts . . . "[9]

Making that second trip to learn more about India helped Margaret turn *Halfway to Freedom* into one of her finest books. Writing was becoming very important to her; it helped her to sort out ideas. It was a way of "digesting" her experiences. What she truly was seeking, Bourke-White realized, was a "rhythm" in her life: "the high adventure . . . balanced with a period of tranquility in which to absorb what I had seen and felt."[10]

Chapter Ten

Life *Doesn't Do Things That Way*

Bourke-White was very much against discrimination. Perhaps it was because she herself was half-Jewish. Others thought the sharecroppers she photographed in the Deep South had made her very sensitive and sympathetic, especially to the problems of black people. Her own fight to keep her place in a man's world may also have shaped her opinion.

All over the world, Bourke-White had seen discrimination and the suffering that it causes. But never as bad as in South Africa. In 1950, *Life* sent Margaret to the land of apartheid (separation of races) to do a photo essay. South Africa then had nearly four times as many black people as white. Yet the whites owned 90 percent of the land and all of the gold and diamond mines, which were the country's big businesses.

It was in the mines that Bourke-White found her story.

Spotting two gold miners she wanted to use as her subjects, she went to the superintendent. She needed the men's names and permission to photograph them. But black miners, the white boss told her, aren't known by names—only by the numbers tattooed on their arms. He agreed to let her take pictures of Numbers 1139 and 5122, but he would have to bring them to a safer area. Where they worked was too dangerous for visitors.

Margaret would not hear of it. "*Life* magazine doesn't do things that way," she informed the superintendent. "Either I photograph them where they really work, or we'll forget the whole thing."[1]

With the usual Bourke-White persistence, she was soon headed down an elevator shaft two miles underground. What little air there was at this depth was hot and humid. On the bottom she spotted Numbers 1139 and 5122, their black skin and sad eyes dripping with constant sweat. In a short time Margaret found herself unable to speak or to move her arms. Seeing the problem, the superintendent quickly led her to a section of the shaft where there was more air, and she felt better. Just two months before, he told her, another visitor had died from the heat and bad air in this mine.

When her shooting was complete, Margaret's group headed for the elevator. Being white, they would go up first, before the black miners. "I left the

mine," she said, "realizing that I had spent only four hours underground, and I would not have to return if my pictures were all right. But these men . . . were destined to spend the better part of their waking hours underground with no hope of escaping the endless routine."[2]

Bourke-White's next stop in South Africa was the Orange Free State, where a gold rush was going on. The white-owned mining companies were sinking new shafts in the area, looking for gold. Because the mines were new, the only way to get into them was to ride down in an open bucket that dangled and swung around in circles as it plunged deep into the earth. In Margaret's bucket rode the foreman and two other men. Yes, the foreman told her, the buckets did sometimes break loose. In fact, just a few weeks earlier a cable had broken, sending a bucket straight to the bottom. That bucket had held only tools, but 17 unlucky men working below it had been killed.

Conditions in the African mines were terrible. This was the land of the underground rains, where the humidity was very high. Many of the shafts went below sea level, so it actually "rained" harder inside the mines than it did above ground. Margaret and her cameras were wrapped in an extra raincoat, but her "eyelids seemed to be pasted together by the torrents which never ceased. . . . I had brought four Rolleiflexes, and

as fast as one became soaked and useless, I started on the next." When the foreman was ready to head up, Margaret recalled, "This was once in my life when I didn't say, 'Just one more.'"[3]

Bourke-White was horrified by the conditions under which these black miners worked. But what she saw in South Africa's wine-producing region angered her even more. There, children worked with adults in the vineyards, helping to pick and process grapes to make wine. Part of the children's pay was in wine. This not only saved the vineyard owners money; it made alcoholics of the children. Making them alcoholics insured that they would buy more and more wine as they grew older. Margaret was outraged. How could she continue to photograph what she saw?

This assignment raised a huge question in Margaret's mind: What should a photographer do when she disapproves thoroughly of the subject she is recording? She hated South Africa's white supremacist policy. But she needed the help and permission of the white business owners in order to take pictures for her assignment. "However angry you are," Bourke-White decided, "you cannot jeopardize your official contacts by denouncing an outrage before you have photographed it. I like to do my work without lying, if I can. [But] telling the truth does not necessarily mean revealing the whole truth."[4]

Getting the story and telling it to the world was
Bourke-White's job. She would do whatever was
necessary to get the story, for her job always came first.
"Work is a religion to me," Bourke-White once said,
"the only religion I have. Work is something you can
count on, a trusted, life-long friend who never deserts
you."[5] Long ago her father had taught her this respect
for work and it stayed with her all her life.

Dedication to her job had brought Margaret Bourke-
White as much fame as one person could want. She
had built a great name for herself. She was proud of her
success. But early in the 1950s, her name was threatened
by the Communist scare that was sweeping the country.

This was the era of McCarthyism, a movement led
by Senator Joseph McCarthy to hunt down Americans
who were supposedly Communists. The thought of
Commnists taking over business and government had
millions of Americans frightened. Across the United
States, both well-known and unknown people were
accused of being Communists. Thousands of them lost
their jobs or had their careers ruined. Often the charges
were false or the facts had been twisted purposely to
hurt a person. Margaret Bourke-White was among
those accused of being a Communist. She was not
about to let her career be ruined, but how could she
save herself from this modern-day witch-hunt?

By 1952 the Korean War had been raging for two

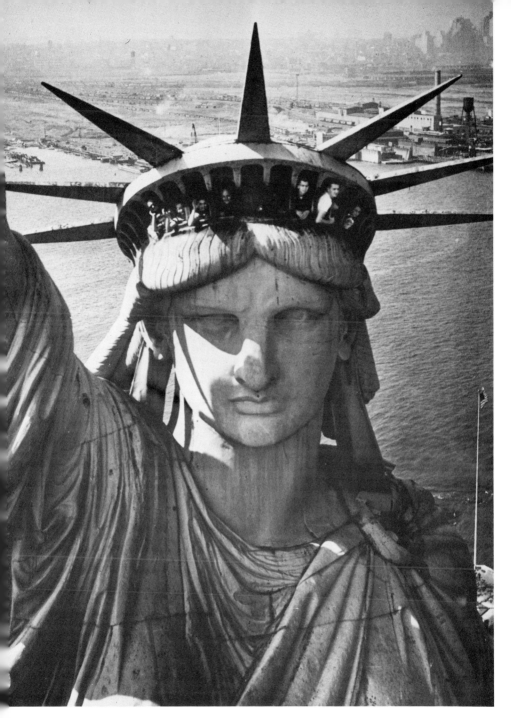

"Solid citizen" Margaret's shot of the Statue of Liberty, 1952

years. North Koreans, aided by the Communists, were fighting against South Koreans, supported by the United Nations. Reporters and photographers had covered the battles from all sides. But Bourke-White had not yet been sent there. She began to see the Korean War as the way to remind millions of readers that she was still a solid citizen and strongly against communism. Once again Bourke-White asked *Life* to send her to the battlefield. As she left New York, her editor told her, "Maggie, take three months if you need it, roaming around Korea, and when you've found a new . . . story you think is *your* story, cable us."[6]

The Korean War, she quickly learned, was being fought much differently than the battles of World War II. Guerrillas were a big part of this war. Guerrillas are small bands of soldiers who work secretly to lead surprise attacks on the enemy. Many of the guerrillas in South Korea were teenagers who had changed sides and joined the North Korean Communists. The Communists had promised them an education, good jobs, and a better way of life if they would become guerrillas.

This war, Bourke-White realized, was turning "friend against friend, and brother against brother. Here was a war of ideas which cut through every village and through the human heart itself. This was my story. But how was I to get it?"[7]

Margaret set out with the South Korean police in search of her story. For weeks at a time she stayed in the wilderness, sleeping in soggy bedrolls or under tables in field huts filled with phones and other communications equipment. *Life* magazine rarely knew where she was, so the staff sent three sets of film and supplies to three different places, hoping at least one set would find her. Most of the time it worked.

After months of recording guerrillas in action, Margaret finally found the story she wanted. One morning the police captain told her that he was holding a guerrilla who had surrendered the night before. For two years this young man, Nim Churl-Jin, had been living in mountain hideouts, fighting as a member of the Red Youth Group. He, like so many others, had joined because the Communists promised him a better life.

Nim Churl-Jin's brother, an important official in their town, had been deeply upset when Churl-Jin joined the guerrillas. Churl-Jin knew he had hurt his brother, but he had very much wanted the good life the Communists promised. Now, he realized, these promises had been only schemes to get kids like himself to become guerrillas. The Communists were not going to do what they had promised. He wanted to quit. He wanted to go home and apologize to his brother. He wanted to go home and find his mother who, he was

sure, must think he was dead.

Hearing all of this, Margaret asked the officer if she could take Churl-Jin home to his mother. The officer agreed. For two days they drove in a jeep over the rocky hills of South Korea while Churl-Jin told Margaret all about guerrilla life in the mountains. As they neared his home, "In a flash, Churl-Jin was out of the jeep and trotting along the path to his village, and I was running after him taking pictures of his back as he ran."[8]

His first stop was at his home, where he surprised his wife and the two-year-old child he had never seen. Margaret's cameras were never still. The story she most wanted, though, was of Churl-Jin's reunion with his mother. But the mother, they were told, was away visiting relatives. Not to be stopped, Margaret directed Churl-Jin back to the jeep to continue the journey. On the way they met his brother, who joined them. Margaret was anxious to press onward before the light faded.

"In a whole lifetime of taking pictures," she later said, "a photographer knows that the time will come when he will take one picture that seems the most important of all. And you hope that everything will be right." It was. The light was nearly gone, but not quite. She had just enough to capture the image she wanted most. Churl-Jin had jumped from the jeep and was running across a brook. "I ran after him, but he was

way ahead of me. . . . And it took me forever, it seems
. . . because it was very slippery and I was trying to keep
my two cameras dry."⁹

She reached Churl-Jin just as his mother was
wrapping her arms around him, crying, "It's a dream.
It can't be true. My son is dead."¹⁰ Then she rocked him
in her arms and began singing to him.

When that picture was published, many people
said it showed more emotion than any photo Bourke-
White had ever taken. When a reporter at *Life* asked her
what made the photo essay on Korea so different from
others, she replied, "This time my heart was moved."¹¹

On this assignment she discovered, "that the quest
for human understanding is a lifetime one that has
no end in sight."¹²

Chapter / Eleven

In the Right Place at the Right Time

All her life Margaret had had a strong and attractive body. Her clothes, her hairstyle, everything about her appearance was very important to her. For years Bourke-White had depended on her nimble body to carry her through any assignment. "Strong men might fall by the wayside," she wrote, "but I was 'Maggie the Indestructible.'"[1]

Then, suddenly, she wasn't. She became aware of her trouble in 1951 at a meeting of the Tokyo Press Club when she staggered as she got up from the lunch table. At first the problem was hardly noticeable. She simply had a strange feeling in her left leg, "not strong enough to dignify by the name of pain."[2] But before long she noticed this feeling had spread to other areas of her left side. She had trouble walking after she had

been sitting for some time.

Bourke-White traveled from doctor to doctor, looking for one who could tell her what was wrong and treat her for it. For three years her efforts were in vain. But in 1954 she finally found a neurologist, a doctor who studies the nervous system, who was able to make a diagnosis. To keep Margaret from worry, the doctor didn't tell her the name of her disease. But she must, he insisted, exercise constantly to keep her body from stiffening. Exercise was more important than rest. To help her exercise, the doctor brought in Mr. Hofkosh, whom Margaret would later call "an archangel."

Crumple newspaper, Mr. Hofkosh told her, to keep strength and control in her hands. From then on, Margaret's life was a continual mound of popcorn-ball-sized newspaper wads. "If I traveled by myself on an airplane, train or bus, when I disembarked, the space under the seat overflowed with popcorn balls."[3]

She must walk four miles a day. She must wring out warm, wet towels to build strength in her wrists. She must color with children's crayons to keep control in her fingers. All these exercises Bourke-White did with the same fierce energy and determination that she tackled every assignment. But she could not deny what was happening to her body. Even her cat brushing against her leg could knock her off balance. "Each step on earth was becoming very labored now and I could

not hide from myself the certain knowledge that each year left me a little bit worse than it found me."[4]

Margaret wanted no one to know. She tried to hide her strange disease. When she traveled, she ate in her room so no one would see that she could no longer cut her meat. Work had always been a great strength in her life. Now it became even more important. She wanted to continue traveling and photographing for *Life*. But more and more often she needed help loading her cameras or putting on her coat. It was hard to hide her illness from her coworkers.

Life continued to give assignments to its star female photographer, even though her editors suspected she was sick. A photo essay on the Jesuits, a religious group, took her from coast to coast and to British Honduras. There, in a run-down shack, Bourke-White prepared to photograph a priest who was visiting a dying old man. To her astonishment, in the face of death the old man was smiling.

Margaret had always been persistent, the last one to leave an assignment. But now she became fiercely insistent. When they were asked to leave the old man's bedside, she cried and pleaded, "We must stay longer. We must." Something about the old man's state was holding her in its grip. Later the reporter who had been with her asked if she had been afraid. She nodded. "My God, how is it possible *not* to be afraid of death?"[5] she said.

Fighting Parkinson's disease, Margaret would walk four miles a day.

It was her own death that she probably feared most. Yet her positive outlook on life became even brighter as her condition grew worse. When she learned, finally, that what she had was Parkinson's disease, she began reading everything she could find about the illness. "Somehow," she wrote, "I had the unshakable faith that if I could just manage to hang on and keep myself in good shape, somewhere a door would open."[6]

She was right. Although little was known about Parkinson's disease when Margaret contracted it, that soon changed. A young doctor named Irving Cooper developed an operation that relieved many Parkinson's patients from their stiffness, their shaking bodies, and their lack of nerve and muscle control. Dr. Cooper could not cure Parkinson's, but he could slow it down. Although the operation was still questioned by many doctors, Margaret decided to try it.

In January 1959, she entered the hospital. "I realized this was an assignment, the greatest in my life. . . . As long as I thought of it in the context of my work, it held no fears for me."[7] The operation was a success, and for Margaret "the next few weeks were a continuous Christmas."[8] She could swing her arms again. Her back straightened. She could get in and out of a car by herself.

But Parkinson's disease is progressive. Although there are drugs to slow down the illness, over time

patients get worse and worse until they die. Margaret said it was like trying to run up a down escalator. She exercised fiercely, and always she turned to her work for strength. Although she had to train herself to type all over again, she wrote her autobiography, *Portrait of Myself*, while she had Parkinson's.

At the urging of her friend and fellow photographer Alfred Eisenstaedt, Bourke-White finally decided to share her story with the world. Eisenstaedt photographed Margaret during her sessions of physical therapy. Margaret herself wrote the story, which ran in a June 1959 issue of *Life*. At a time when most public heroes did not talk or write about their private lives, Margaret Bourke-White had once again become a pioneer. She hoped that the story of her struggle with illness would help other people. In 1960, her bout with Parkinson's was made into a national television special, *The Margaret Bourke-White Story*.

By 1963, when *Portrait of Myself* was published, Parkinson's had taken control of Bourke-White's body. Although publisher Henry Luce had earlier promised her *Life*'s first assignment to the moon, she would not be the one to go. She could no longer take pictures or give lectures. But something new had come into her life in their place. During her illness she had developed a much deeper understanding of people.

Her battle with Parkinson's was, she wrote, "one

of the great experiences of my life. I would not be without it even if I had the power to wipe it out of my past." As horrible as the disease had been and would continue to be, she had grown because of it. "It brought me closer to other human beings in a way I cannot put into words. To me it was a profound experience."[9]

By the 1960s, the age of the photo essay was coming to an end. Television was taking over as the major source of picture news. The great days of *Life* as a photo/news magazine were nearly over. Throughout her career, Bourke-White's life had followed the route of *Life* magazine. Now, like the magazine, it was nearing its end. After fighting Parkinson's disease for nearly 20 years, Margaret Bourke-White died on August 27, 1971. The last weekly issue of *Life* was published in late 1972.

Vicki Goldberg, who wrote a biography of Margaret Bourke-White, says that "no still photographer is likely ever to repeat her success, for the conditions of that success cannot be re-created."[10] Margaret Bourke-White was born into the golden age of news photography, when the photo essay and the big picture magazines were kings and queens of the media. Those days are over. Today television, motion picture, and video are kings and queens. Who can say what will follow? But by "some special graciousness of fate," Bourke-White said of herself, "I [was] deposited—as all good photographers like to be—in the right place at the right time."[11]

Chapter Notes

CHAPTER 1

1. Margaret Bourke-White, *Portrait of Myself* (New York: Simon and Schuster, 1963), 90.
2. Ibid, 11.
3. Vicki Goldberg, *Margaret Bourke-White: A Biography* (New York: Harper & Row, 1986), 12.
4. Bourke-White, *Portrait of Myself*, 21.
5. Ibid, 14.
6. Ibid, 21.
7. Ibid, 22.
8. Ibid, 22.
9. Ibid, 24.
10. Goldberg, *Margaret Bourke-White: A Biography*, 9.

CHAPTER 2

1. Goldberg, *Margaret Bourke-White: A Biography*, 20.
2. Ibid, 24.
3. Ibid, 26.
4. Ibid, 32.
5. Ibid, 55.
6. Bourke-White, *Portrait of Myself*, 27.
7. Ibid, 29.
8. Ibid, 30.
9. Ibid, 32.

CHAPTER 3

1. Bourke-White, *Portrait of Myself*, 14.
2. Jonathan Silverman, *For the World to See* (New York: Viking Press, 1983), 8.
3. Bourke-White, *Portrait of Myself*, 14.
4. Ibid, 50.
5. Ibid, 60.

6. Ibid, 62.
7. Ibid, 63.
8. Ibid, 70.
9. Ibid, 71.
10. Ibid, 78.
11. Ibid, 80.
12. Sean Callahan, ed., *The Photographs of Margaret Bourke-White* (New York: Bonanza Books, 1975), 25.
13. Bourke-White, *Portrait of Myself*, 93.
14. Ibid, 96.
15. Ibid, 100.
16. Ibid, 102.
17. Ibid.

CHAPTER 4
1. Bourke-White, *Portrait of Myself*, 81.
2. Ibid, 85.
3. Ibid, 80.
4. Goldberg, *Margaret Bourke-White: A Biography*, 145.
5. Bourke-White, *Portrait of Myself*, 88.
6. Ibid, 110.
7. Goldberg, *Margaret Bourke-White: A Biography*, 156.
8. Bourke-White, *Portrait of Myself*, 110.
9. Bourke-White, "Dust Changes America," *Nation*, May 22, 1935.
10. Bourke-White, *Portrait of Myself*, 110.
11. Ibid, 112.
12. Ibid, 113.

CHAPTER 5
1. Goldberg, *Margaret Bourke-White: A Biography*, 163.
2. Bourke-White, *Portrait of Myself*, 117.

3. Ibid, 120.
4. Ibid, 121.
5. Ibid, 125.
6. Goldberg, *Margaret Bourke-White: A Biography*, 166.
7. Bourke-White, *Portrait of Myself*, 125.
8. Ibid, 130.
9. Ibid, 133.
10. Goldberg, *Margaret Bourke-White: A Biography*, 170.
11. Ibid, 191.
12. Bourke-White, *Portrait of Myself*, 138.

CHAPTER 6

1. Otha, C. Spencer, "Twenty Years of *Life*" (Dissertation, University of Missouri, 1958) 169.
2. Bourke-White, *Portrait of Myself*, 147.
3. Ibid, 149.
4. Ibid, 150.
5. Ibid, 152.
6. Callahan, *The Photographs of Margaret Bourke-White*, 25.
7. Bourke-White, *Portrait of Myself*, 164.
8. Ibid, 166.
9. Ibid, 159.
10. Ibid, 159-160.

CHAPTER 7

1. Silverman, *For the World to See*, 80.
2. William Shirer, *The Rise and Fall of the Third Reich* (New York: Simon and Schuster, 1960), 365.
3. Goldberg, *Margaret Bourke-White: A Biography*, 226.
4. Bourke-White, *Shooting the Russian War* (New York: Simon and Schuster, 1942), 115.
5. Bourke-White, *Portrait of Myself*, 177.

106

6. Ibid, 182.
7. Bourke-White, *Shooting the Russian War*, 231.
8. Goldberg, *Margaret Bourke-White: A Biography*, 254.
9. Ibid, 255.
10. Bourke-White, *Portrait of Myself*, 197.

CHAPTER 8
1. Bourke-White, *Portrait of Myself*, 210.
2. Ibid, 209.
3. Ibid, 217.
4. Ibid, 231.
5. *Life*, March 1, 1943, Volume 14, No. 9, 17-23.
6. Bourke-White, *Portrait of Myself*, 235.
7. Ibid, 246-247.
8. Ibid, 250.
9. Ibid, 257.
10. Silverman, *For the World to See*, 152.
11. Bourke-White, *Portrait of Myself*, 259.
12. Ibid.
13. Ibid, 260.

CHAPTER 9
1. Bourke-White, *Portrait of Myself*, 273.
2. Callahan, *The Photographs of Margaret Bourke-White*, 26.
3. Larry Collins and Dominique Lapierre, *Freedom at Midnight* (New York: Avon, 1976), 36.
4. Bourke-White, *Portrait of Myself*, 283.
5. "Words About Pictures," *Infinity* (American Society of Magazine Photographers, June 1958), 7.
6. Bourke-White, *Portrait of Myself*, 293.
7. Ibid, 295
8. Ibid, 299

9. Goldberg, *Margaret Bourke-White: A Biography*, 314.
10. Bourke-White, *Portrait of Myself*, 300.

CHAPTER 10

1. Bourke-White, *Portrait of Myself*, 315.
2. Ibid, 316.
3. Ibid, 320.
4. Ibid, 322.
5. Goldberg, *Margaret Bourke-White: A Biography*, 325.
6. Bourke-White, *Portrait of Myself*, 330.
7. Ibid, 332
8. Ibid, 352.
9. Ibid, 356.
10. Ibid.
11. Goldberg, *Margaret Bourke-White: A Biography*, 336.
12. Ibid, 337.

CHAPTER 11

1. Bourke-White, *Portrait of Myself*, 359.
2. Ibid, 358.
3. Ibid, 360.
4. Ibid, 362.
5. Goldberg, *Margaret Bourke-White: A Biography*, 345.
6. Bourke-White, *Portrait of Myself*, 368.
7. Ibid, 370.
8. Ibid, 371.
9. Goldberg, *Margaret Bourke-White: A Biography*, 356–357.
10. Ibid, 360–361.
11. Bourke-White, *Portrait of Myself*, 380.

Appendix
Margaret Bourke-White: A Time Line

1904–Margaret is born in the Bronx, New York, on June 14.

1922–Joseph White, Margaret's father, dies of a massive stroke. Her great love for her father and his interest in photography led her, she claimed, to sign up for a photography course at the Clarence H. White School later that year.

1924–Margaret marries "Chappie," Everett Chapman, on Friday the thirteenth of June. They are divorced two years later.

1929–Receives a cable from Henry R. Luce, publisher of *Time* magazine, asking her to come to New York for a meeting. Begins working for *Fortune*, Luce's new industrial magazine, later that year.

1930–Moves the Bourke-White studio to New York's Chrysler Building. Leaves for Europe to photograph German and Russian industry for *Fortune*.

1936–Mother, Minnie, dies. Margaret and writer Erskine Caldwell head south to begin work on *You Have Seen Their Faces*. September 4: Margaret signs contract to work for the new *Life* magazine.

1939–Bourke-White and Erskine Caldwell are married in Silver City, Nevada, on February 27.

1941–*Life* sends Bourke-White to Russia to photograph Stalin

and the bombing of Moscow during World War II.

1942–The troopship on which Bourke-White is a passenger is torpedoed by the Germans on December 22.

1943–*Life*'s Bourke-White goes on her first bombing run over North Africa, then on to photograph the fierce fighting in Italy.

1945–Bourke-White in Germany to record the end of World War II. Photographs the horror of the Buchenwald concentration camp.

1946–Arrives in India to cover the country's break from the British Empire and the birth of Pakistan. Also photographs Gandhi at his spinning wheel and after his assassination.

1950–In South Africa to photograph workers in the gold and diamond mines.

1952–Photographs the Korean War from the perspective of guerrilla fighters.

1954–Margaret is diagnosed as having Parkinson's disease.

1960–*The Margaret Bourke-White Story*, about her fight against Parkinson's disease, is shown on nationwide television.

1971–Margaret Bourke-White dies on August 27.

Selected Bibliography

Bourke-White, Margaret. *Dear Fatherland, Rest Quietly.* New York: Simon and Schuster, 1946.

Bourke-White, Margaret. *Portrait of Myself.* New York: Simon and Schuster, 1963.

Bourke-White, Margaret. *Shooting the Russian War.* New York: Simon and Schuster, 1942.

Bourke-White, Margaret. *They Called It "Purple Heart Valley."* New York: Simon and Schuster, 1944.

Caldwell, Erskine, and Bourke-White, Margaret. *You Have Seen Their Faces.* New York: Viking Press, 1937.

Callahan, Sean, ed. *The Photographs of Margaret Bourke-White.* New York: Bonanza Books, 1975.

Collins, Larry, and Lapierre, Dominique. *Freedom at Midnight.* New York: Simon and Schuster, 1975.

Goldberg, Vicki. *Margaret Bourke-White: A Biography.* New York: Harper & Row, 1986.

Shirer, William. *The Rise and Fall of the Third Reich.* New York: Simon and Schuster, 1960.

Siegel, Beatrice. *An Eye on the World.* New York: Frederick Warne & Co., 1980.

Silverman, Jonathan. *For the World to See.* New York: Viking Press, 1983.

Index

DATE